To Walt Disney,

who gave two young, ambitious songwriters

the opportunity, courage, and confidence to reach higher

and achieve more than they ever dreamed possible.

And to all young dreamers,

should one of your wildest dreams come true,

remember to say thank you.

-R. M. S.

For dearest Adrienne.

My partner, colleague, and friend.

Thank you for joining me on this magical journey.

-F. N.

A Kiss Goodnight

Written by

Richard M. Sherman

and

Brittany Rubiano

Illustrated by

Floyd Norman

and

Adrienne Brown Norman

Dısnep
EDITIONS

Los Angeles • New York

The Birth of a Song

The question I have been asked most frequently throughout the six decades of my songwriting career is "What comes first, the words or the music?" The answer invariably is "Neither." The mark of a good song is most definitely born from a third ingredient: the idea.

Ideas are formed from everyday life. Loss, love, doubt, regret, funny or sad situations, flashes of wit or wisdom—all can trigger song ideas. But many of the best song ideas are derived from the inspiration a good story can evoke. In the case of the Sherman brothers, many of our best songs were sparked by the characters and adventures we found in *The Jungle Book*, *Tom Sawyer*, *Charlotte's Web*, *Winnie the Pooh*, *Chitty Chitty Bang Bang*, and, of course, *Mary Poppins*. However, each of those songs is part of a larger entity, a song score, created to help tell a particular story.

The independent or popular song is an orphan, derived from and related to nothing but itself. Songwriters are always on the alert for a good idea or a "hook" to inspire their music and lyrics. Sometimes a hook just drops into your lap. But sometimes that great idea can take half a century to emerge.

I vividly recall a lovely spring evening in 1963. At that time, my brother Robert and I were enjoying our third year as Walt Disney's staff songwriters. My wife, Elizabeth, and I had spent the entire day taking in the fabulous sights, sounds, and experiences of Disneyland. We had lingered long after most of the day's guests had departed when I noticed a lone figure slowly strolling down Main Street, looking in the storefront windows. That lone figure was Walt Disney.

I told my wife I wanted to let the boss know how much we loved our day at his park. Walt approached us with a smile, saying, "Hello, Richard. Shouldn't you be on your way home by now?" I said, "Walt, we just had to thank you for the most wonderful time today. In fact, when the fireworks started and the music was playing and Tinker Bell flew across the sky, I was so overcome with happy emotions that I was crying." Walt looked me straight in the eye and with a little smile said, "You know, I do that every time. . . . Now drive home carefully." With a fond wink, Walt headed for his apartment above the fire station.

Over half a century later, I was asked to participate in the Diamond Jubilee, a

project for Disneyland's sixtieth anniversary. It was then I learned the little-known story about the park fireworks that have been enchanting millions of Disneyland guests for decades.

As a little boy in Marceline, Missouri, Walt rarely, if ever, had money for toys or amusements. But every Fourth of July, he'd burst with joy, because he could see free fireworks shows all over town. The brilliant colors and patterns of the explosions always triggered his fertile imagination and inspired his boundless creativity. Years later, when Walt and his Imagineers were completing Disneyland, he wanted to say thank you to all his guests when they left the park. His gratitude would come in the form of free fireworks (with the added touches of music and a flying Tinker Bell). He referred to this as "a kiss goodnight."

Now, there's an idea for a song! And what a hook! I immediately pictured that little boy who became the greatest entrepreneur of the twentieth century, that same great man who winked at me one night at Disneyland. I just had to write this song. I had to express how I imagined a young Walt was feeling as he watched magic dancing in the sky.

Walt Disney's limitless ambition, his incredible storytelling talents, and, above all, his love for all mankind continue to inspire, entertain, and educate millions upon millions of people throughout the world. I'm certain his great legacy will live on throughout time. But I think it's especially wonderful to remember that a poor little boy in Missouri, one century ago, dreamed big dreams. And when one of his greatest dreams, Disneyland, became a reality, he simply wished to thank all his guests for coming with "a kiss goodnight."

Richard M. Sherman

Things to Come

The series of offices near the northeast section of the Animation Building was known as E-wing, or simply 1E. Configured differently from the rest of the building's wings, which were occupied by animation artists, 1E was a mystery. We were young artists still learning our way around Walt Disney Productions, and this unique wing down the hall from our work space was an area we had not yet discovered. What was in this unusual wing? we wondered.

One morning, we left our drawing boards and made our way down the hallway for an uninvited visit to 1E. Once we were inside, our eyes widened as we observed a group of talented Disney artists creating theme park attractions. These were future Disneyland attractions yet to be fabricated and constructed. Even though Disneyland had already opened to the public, the Old Maestro was hardly finished with his latest masterpiece, so he had his artists and designers busily creating even more magical wonders. Since the term "Imagineer" had not yet been coined, the special artists were known simply as WED employees—WED being the initials of the boss, Walter Elias Disney. After entertaining audiences with innovative and imaginative animated motion pictures, the Old Maestro had moved entertainment to a whole new level. Now the Disney magic could be a totally immersive experience enjoyed in a special place called Disneyland. Visitors were invited to take a trip down the Mississippi on an old paddle wheeler or soar into space toward the Red Planet—adventures not unlike the Disney motion pictures. You could travel back to a quieter and simpler America on Main Street, U.S.A. or chat with your favorite animated cartoon characters. All this could be yours for the price of a ticket to Disneyland.

In time, the magicians of 1E would vacate the space in the Animation Building to join their colleagues in nearby Glendale. It would appear Walt Disney had created his own start-up: a unique Skunk Works that would continue to create wonders for his special land, a park that Walt proudly announced would never be finished as long as there was imagination in the world. Eventually the company gained a new name and the employees a new title. They were Imagineers. A unique group of artists and technicians, they were a modern-day version of wizards, able to conjure up whatever the boss dreamed.

A trip to Disneyland was a unique experience. It was an entertainment that promised much and gave even more. After guests had spent an exhausting yet exhilarating day at the park, Walt Disney had one last gift to offer them. It harkened back to a special experience in a meadow in Marceline during his days as a young farm boy. Those had been tough times economically, and entertainments were few. During those difficult days, the young lad had looked forward to a night once a year when the sky would become a blaze of fire and light. The images in the night would ignite his imagination, and he began to see wonders in the sky: magical creations he would one day share with all of us.

Walt Disney's unique ability as a storyteller eventually became known around the world. However, it appeared the Old Maestro had no such pretentions and preferred to think of himself as simply a "gag man."

On a quiet Saturday morning in Napa Valley, I sat with Walt's elder daughter, Diane Disney Miller, and we chatted about her famous dad. Diane spoke of her father's infectious enthusiasm and work ethic. "Dad was always looking forward," she said. "He had a childlike wonder and saw incredible possibilities in everything that came his way." It would appear Walt Disney was the ultimate optimist as well as a visionary who knew a better world was possible if all of us shared his dreams—dreams that included everything from a quiet audience with President Abraham Lincoln to the construction of a massive City of Tomorrow. "That was my dad," said Diane. "Always the same simple farm boy who dreamed of bigger things."

Of course, I was lucky enough to sit in meetings with the Old Maestro back in the sixties. The sessions were often tough and demanding, but the end result would be worth it. Though Walt rarely lost his temper, he insisted we all give our best. A job half-done would not be tolerated. Aware of audience expectations, Walt Disney was determined to exceed them.

Years later, Walt Disney would remember that childhood experience—the magical show in the summer night sky that had brought him such joy. A trip to Disneyland would not be complete without a final gift and a connection to childhood and the past. For all those who journeyed to Walt Disney's magic kingdom, it would be a fond good-bye and a kiss goodnight.

Floyd Norman

Long ago, there was
a farm in Missouri . . .

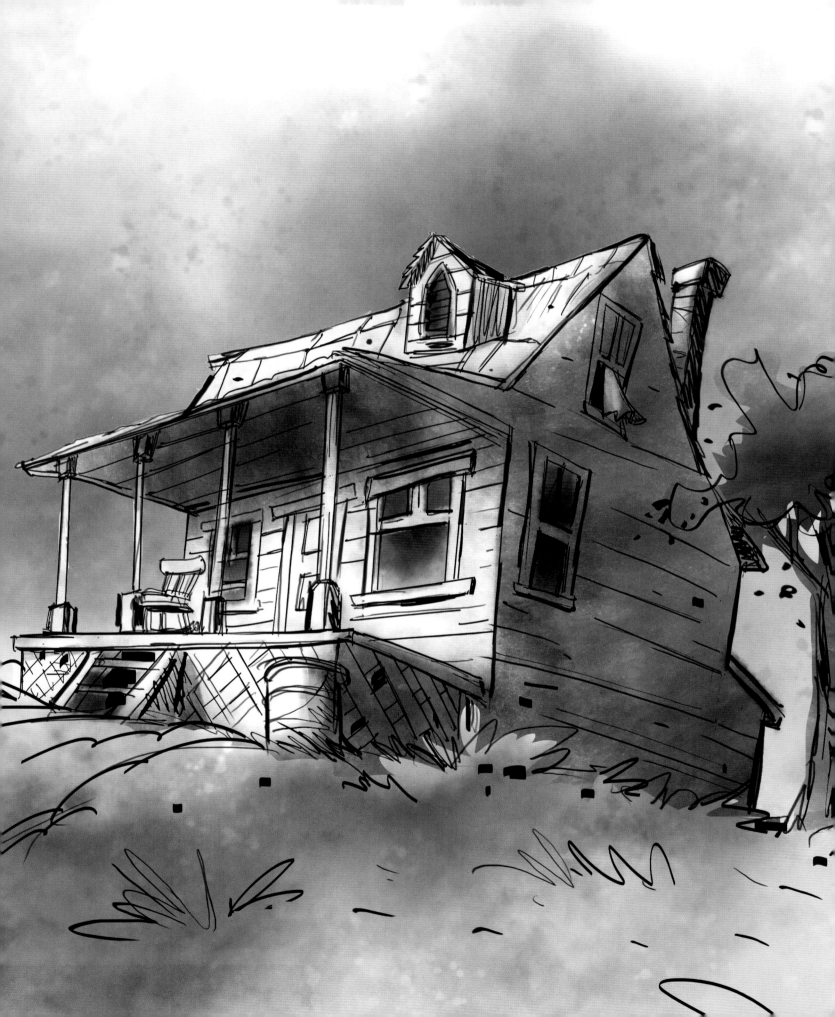

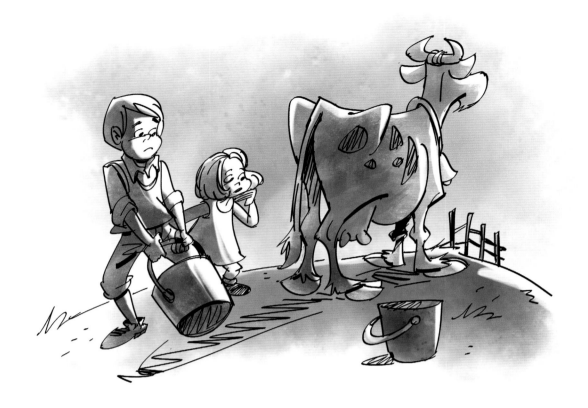

where there were always chores to be done.

There was a six-year-old boy who
saw what others didn't see.

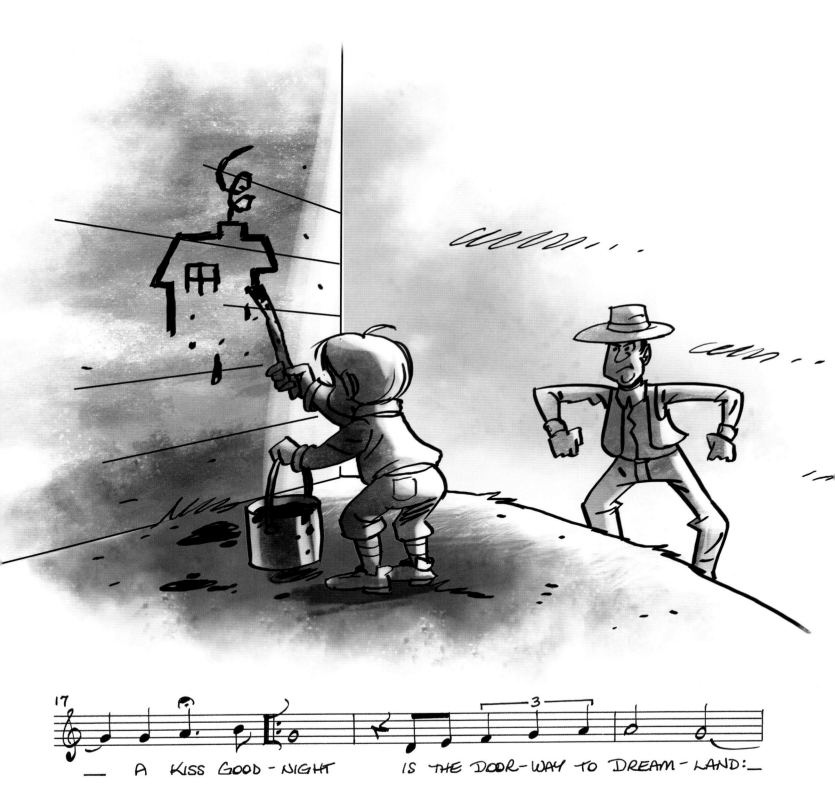

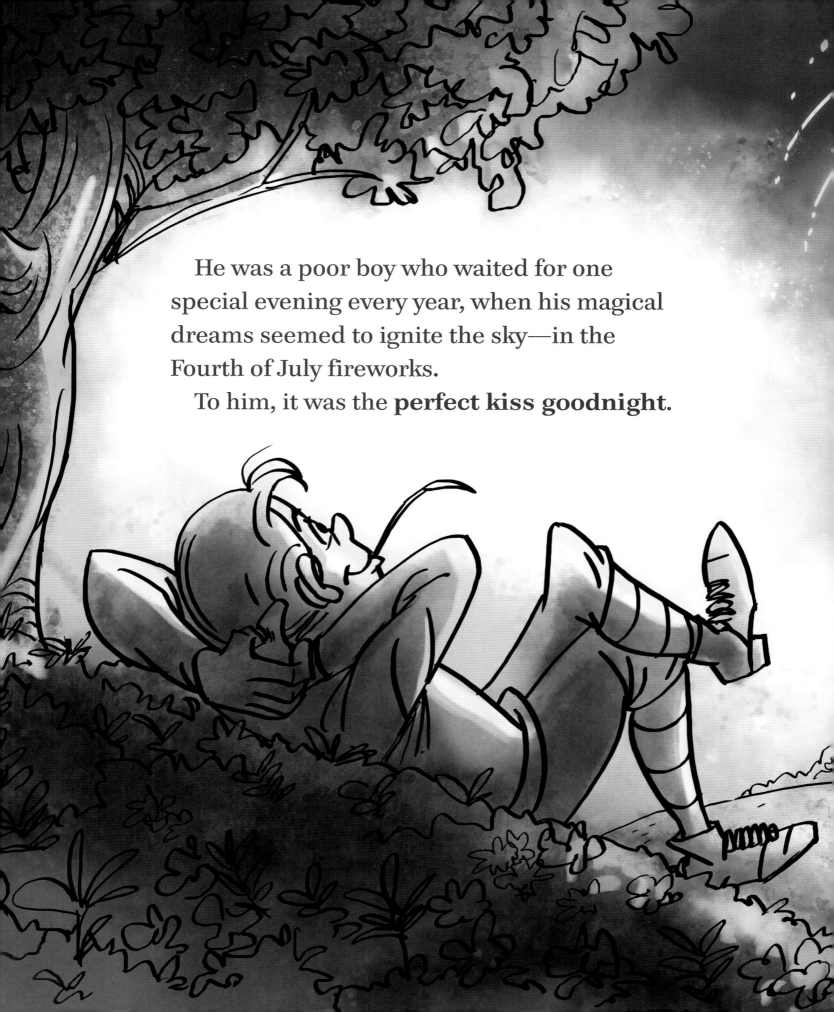

He was a poor boy who waited for one special evening every year, when his magical dreams seemed to ignite the sky—in the Fourth of July fireworks.

To him, it was the **perfect kiss goodnight**.

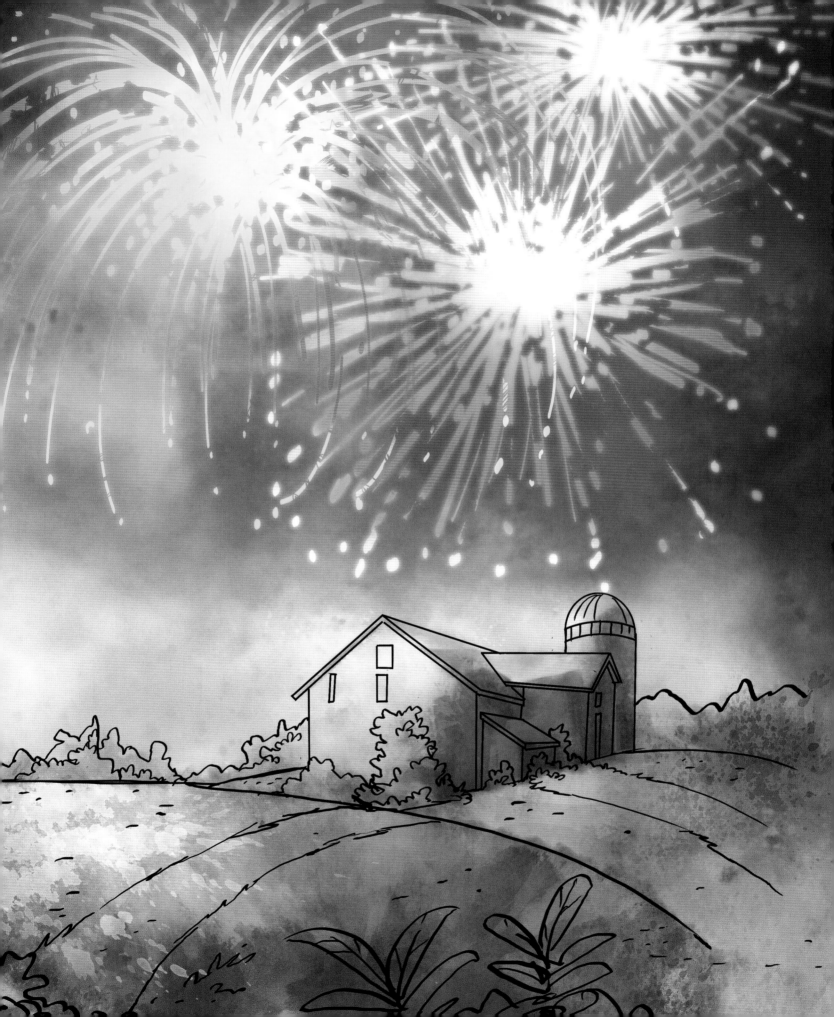

And he was inspired.

When he was ten years old, the little boy had
long paper routes early in the morning and late
in the evening to help his family pay the bills.

But that boy still found ways to share the magic he saw
with others, including the **dreams of his heroes**.

When he was fifteen years old, the boy worked
on the railroad, selling sandwiches, cold drinks,
and newspapers.

21 A KISS GOOD-NIGHT IS WHERE MEM-'RIES BE-GIN.

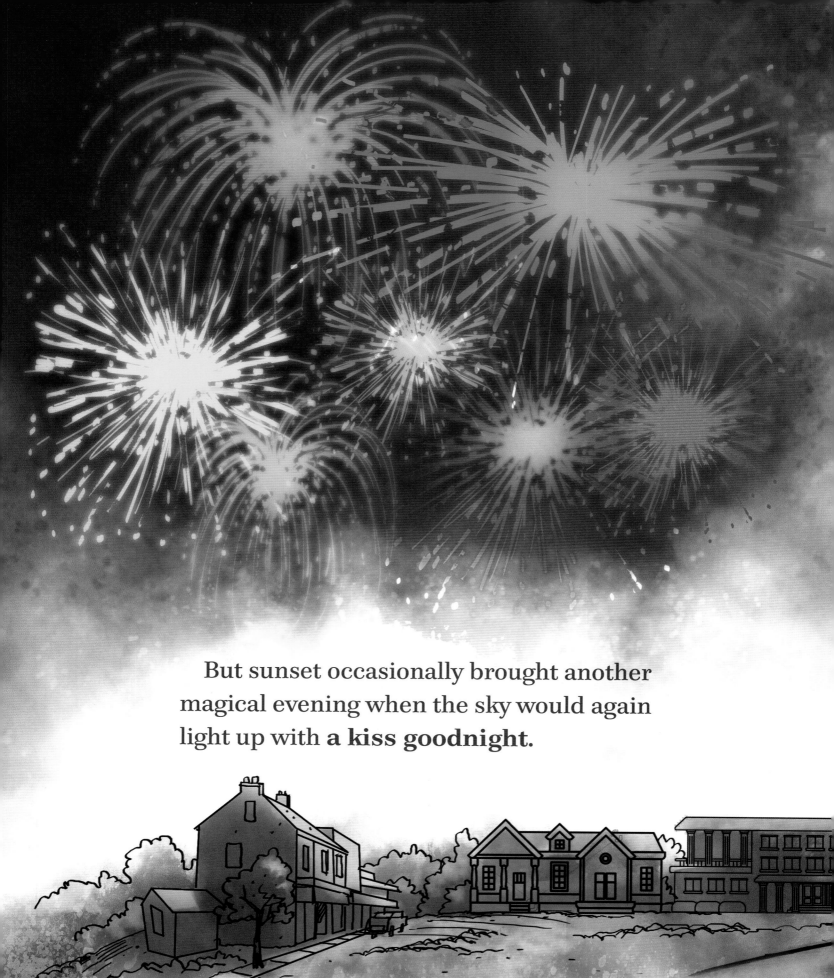

But sunset occasionally brought another magical evening when the sky would again light up with **a kiss goodnight.**

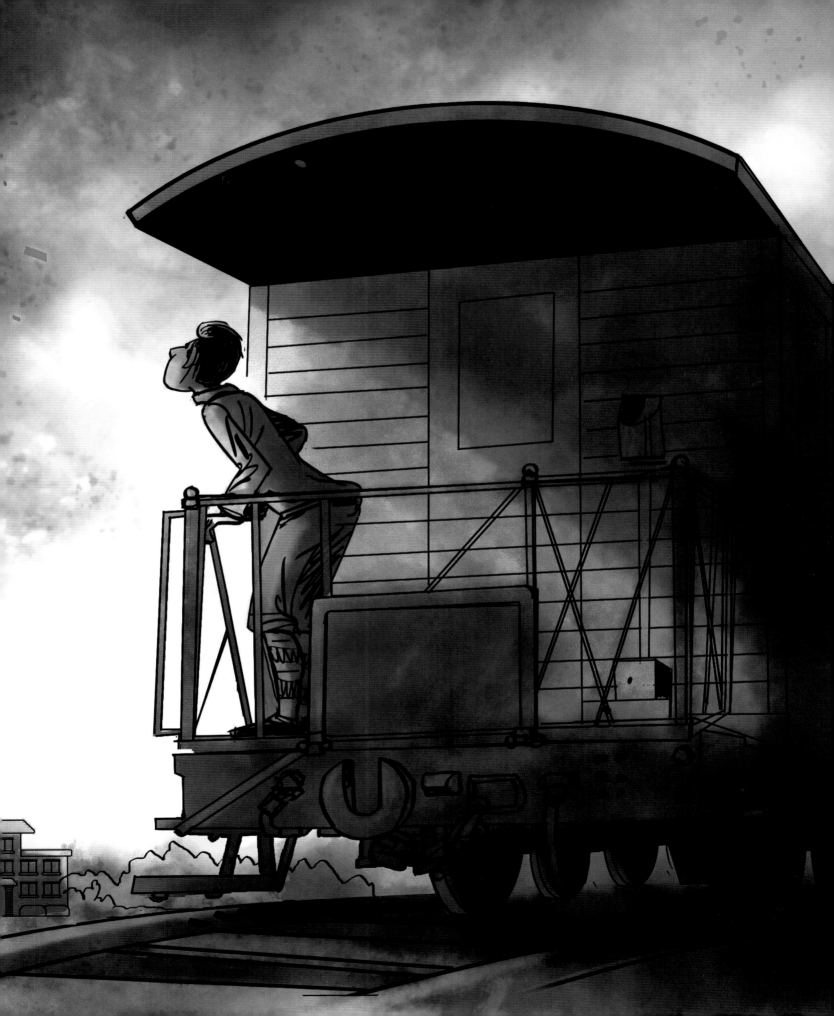

And he was inspired once more . . .
inspired to tell more stories.

Later, when the boy
became a young man,
he used his talents
at his high school
newspaper.

Next he volunteered to drive an ambulance overseas after World War I . . .

learning entirely new skills.

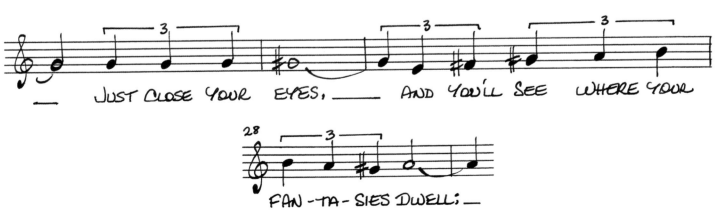

But the **magic was always there.**
And the young man felt eager to go home
and start his own business so he could share
his vision with the world.

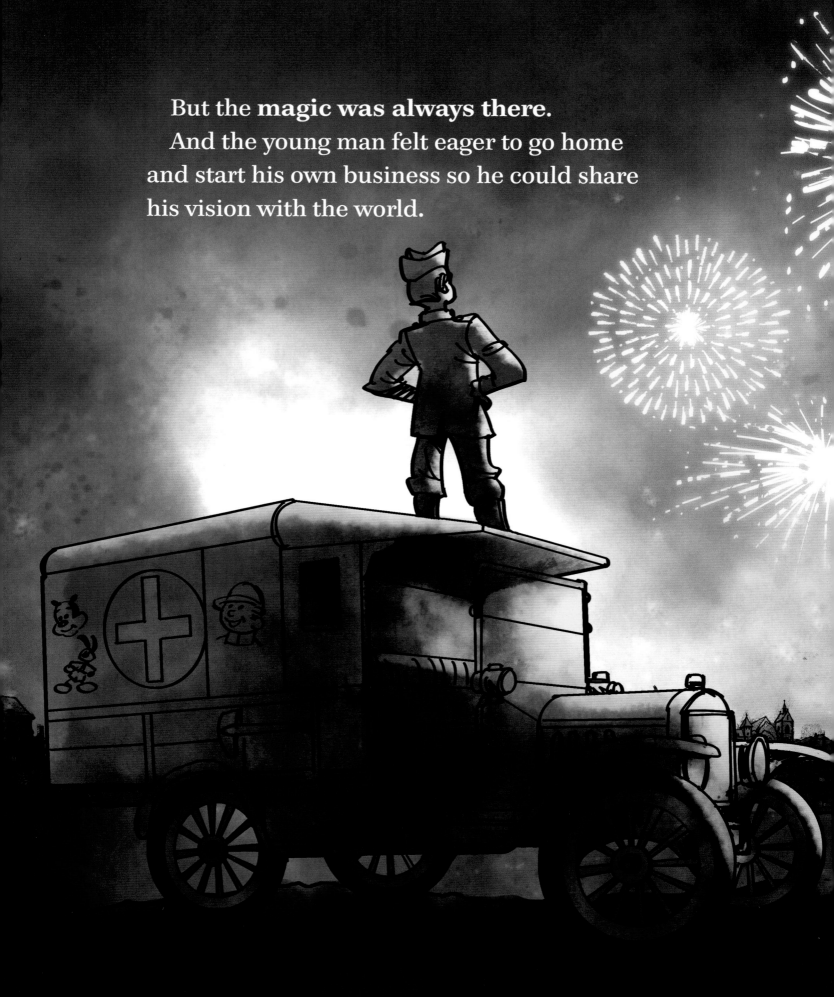

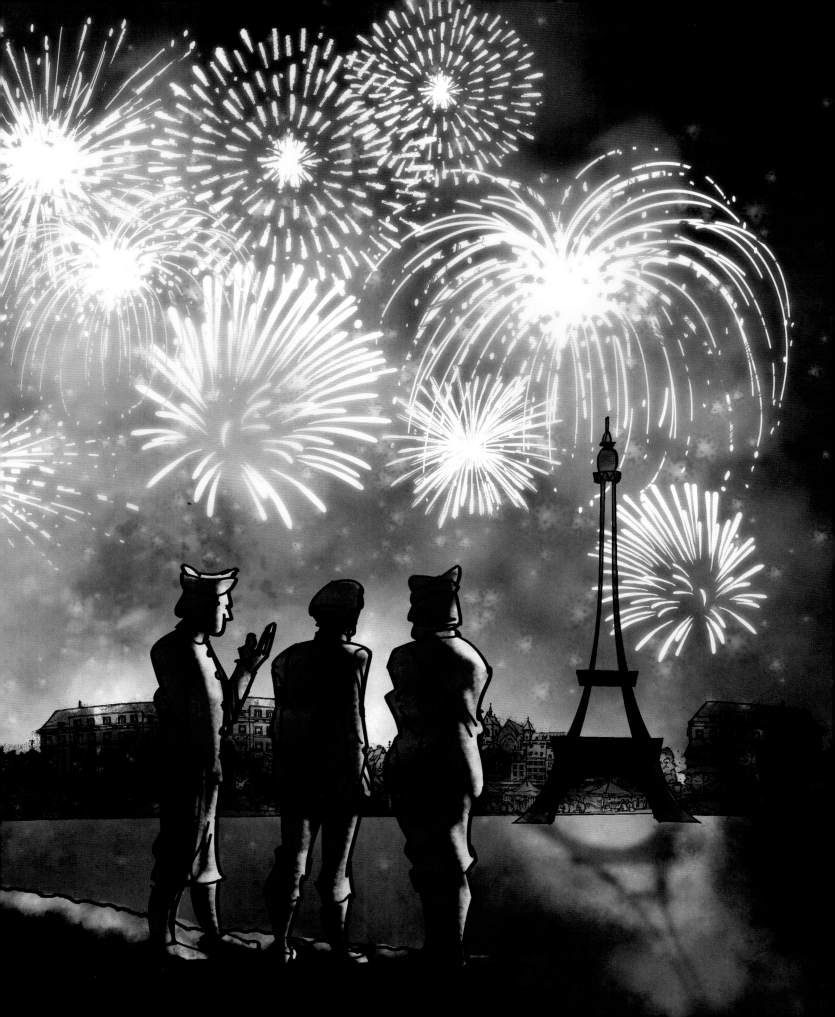

There were triumphs.

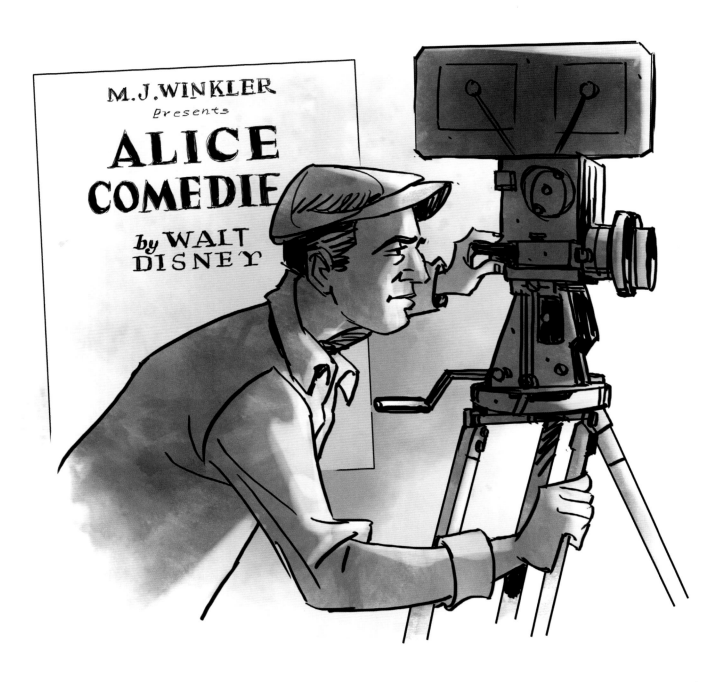

There were failures.

28 TO YOUR SUR-PRISE,___ WHAT A FAB-U-LOUS TALE THEY TELL.

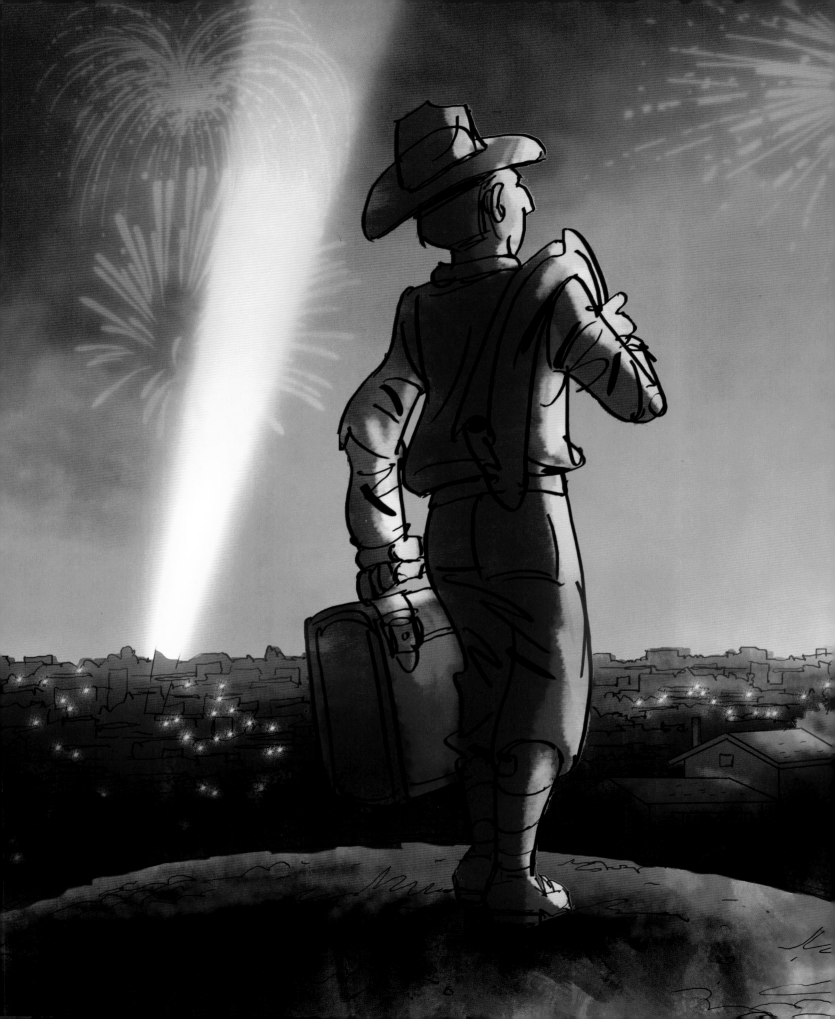

But his dreams and ambitions never failed him.

And just when he needed it most, there was **a new kind of kiss goodnight** lighting up the sky, guiding his way.

At age twenty-one,
the young man went
on a new adventure to
a new land . . .

where he and his brother started a scrappy
little company that would tell new stories.

Though there were more setbacks, he always discovered the magic again. He lost a rabbit . . .

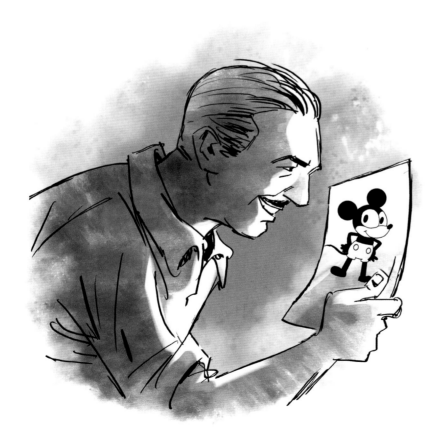

but found a mouse.

Oh, boy, did he find one!

Fifteen years later, the man was sharing his magic in groundbreaking new ways.

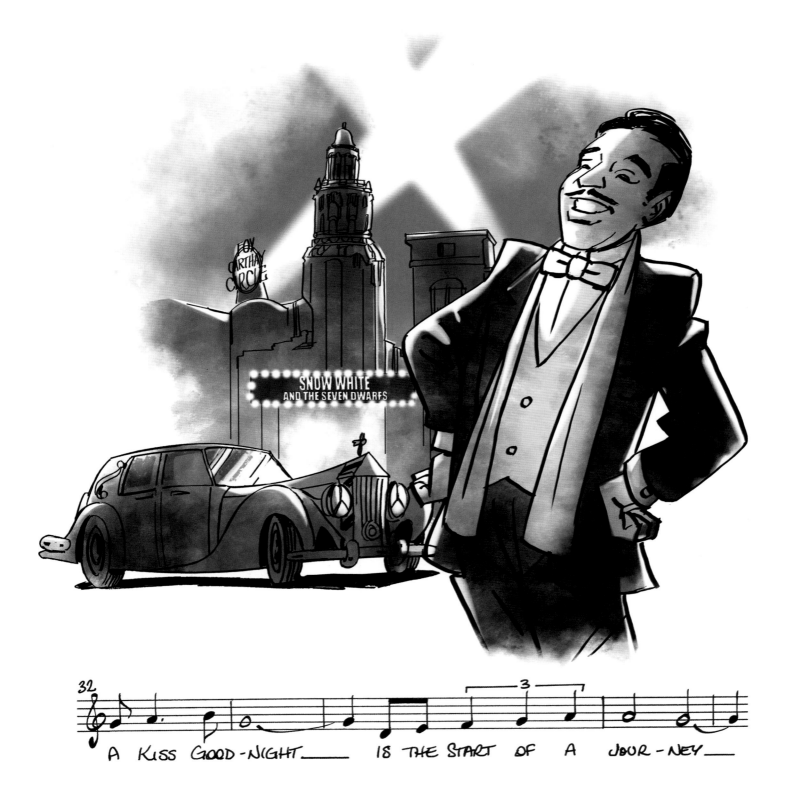

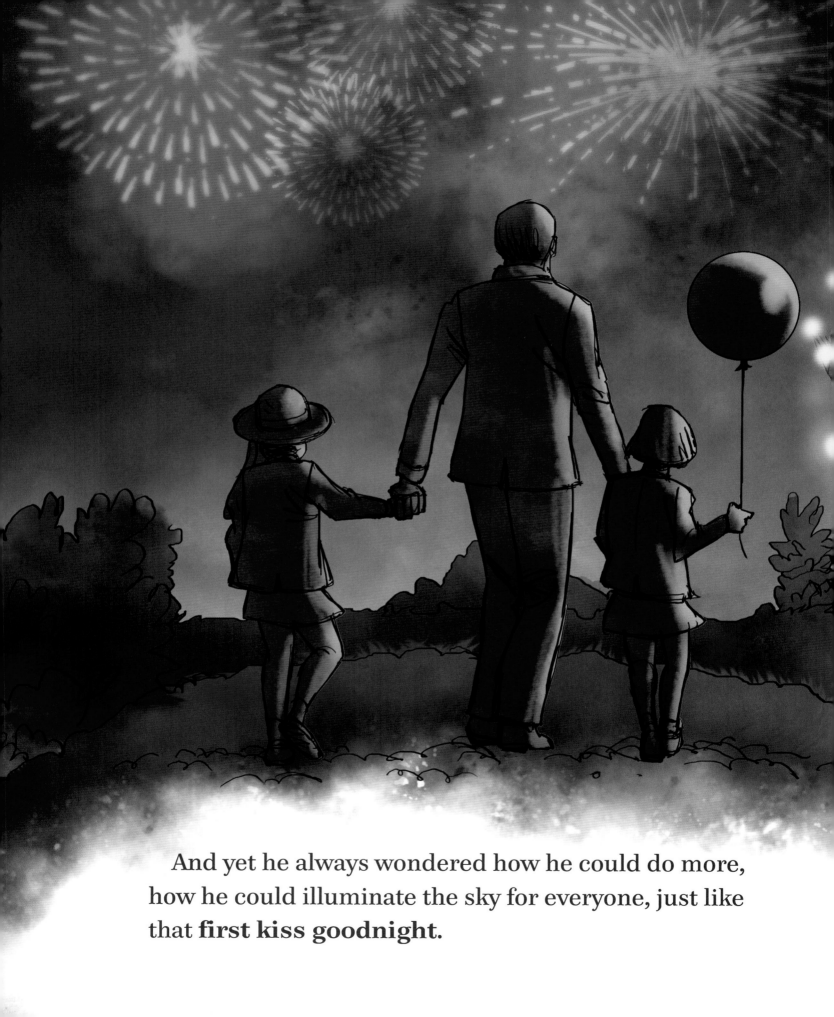

And yet he always wondered how he could do more, how he could illuminate the sky for everyone, just like that **first kiss goodnight.**

He had many new stories to tell, but he wanted to tell them better than anyone had ever told stories before.

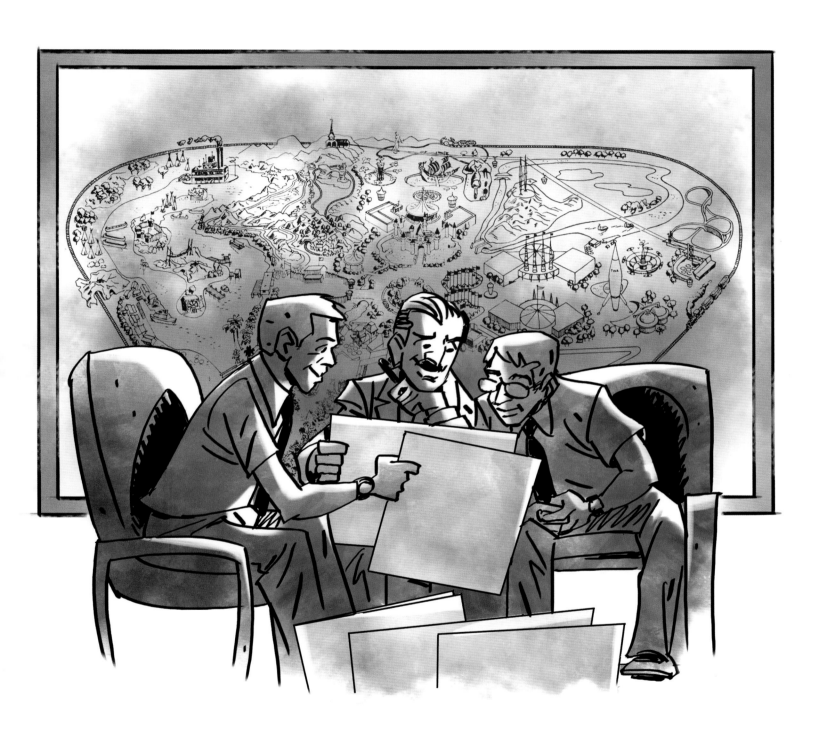

And then he had a dream to create
an entire new land.

He added an **incredible, magical something** that was missing from the plans.

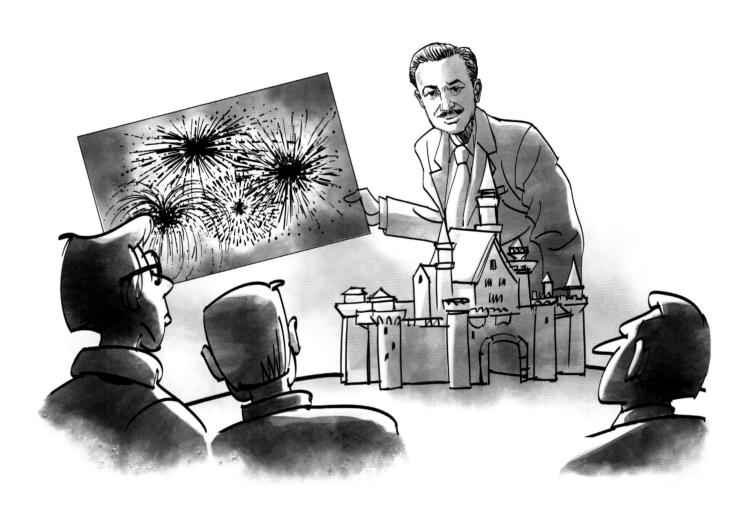

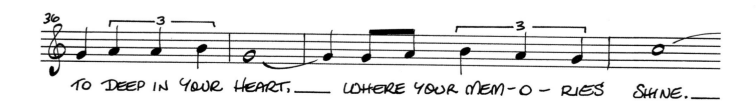

TO DEEP IN YOUR HEART, WHERE YOUR MEM-O-RIES SHINE.

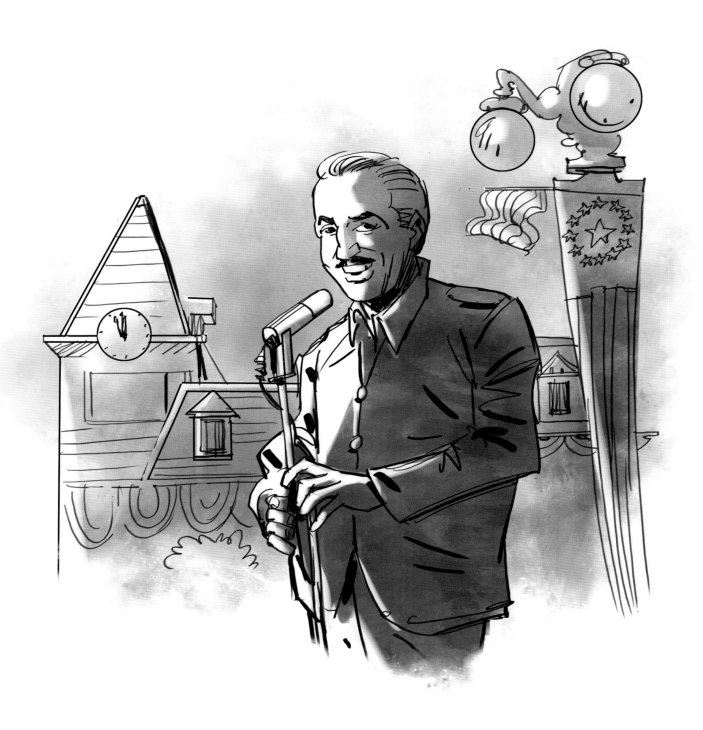

And when the man opened his land of wonders and imagination to the world, each night he would thank his guests for coming . . .

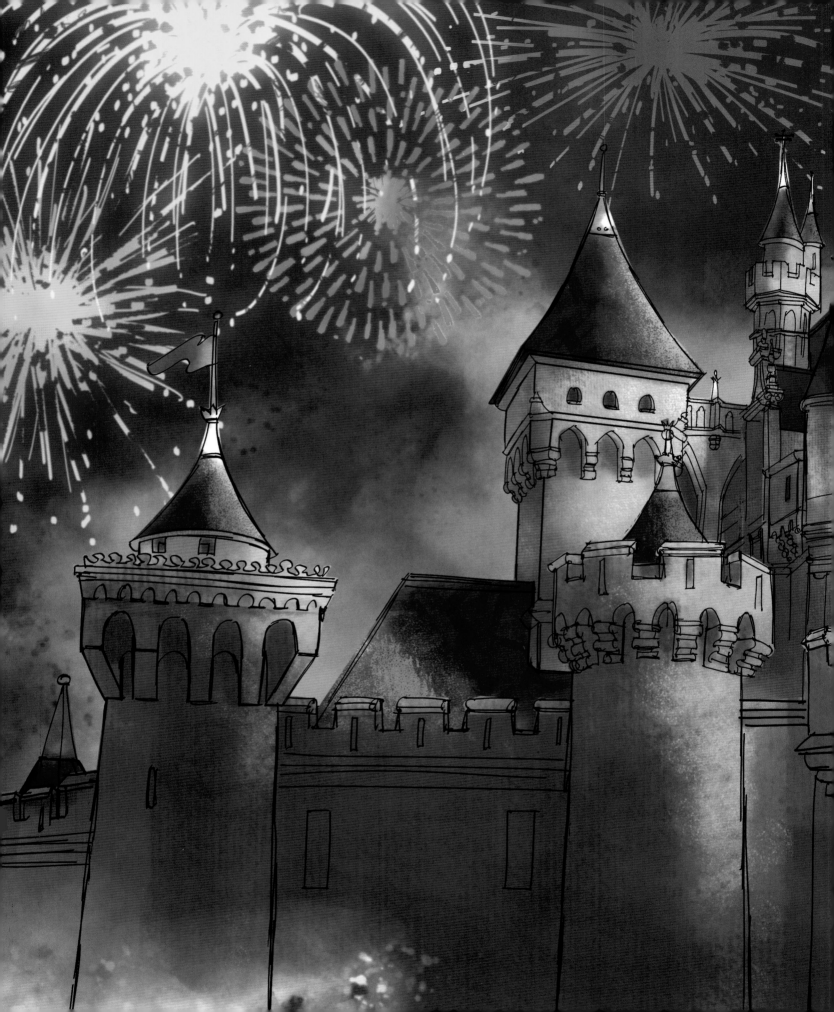

with **a kiss goodnight.**

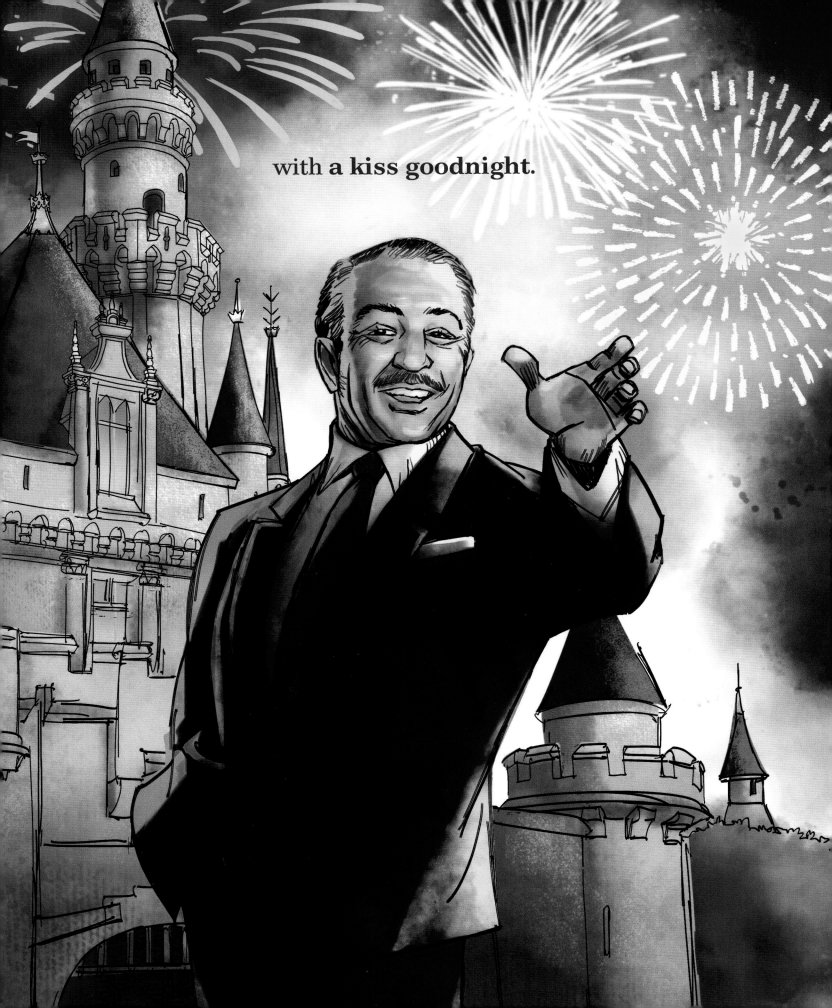

As the years passed, there were more stories to be told.

ALL THE JOY___ AND THE WON-DER YOU FEEL ON YOUR

There was **more magic** to share.
And every evening, for everyone . . .

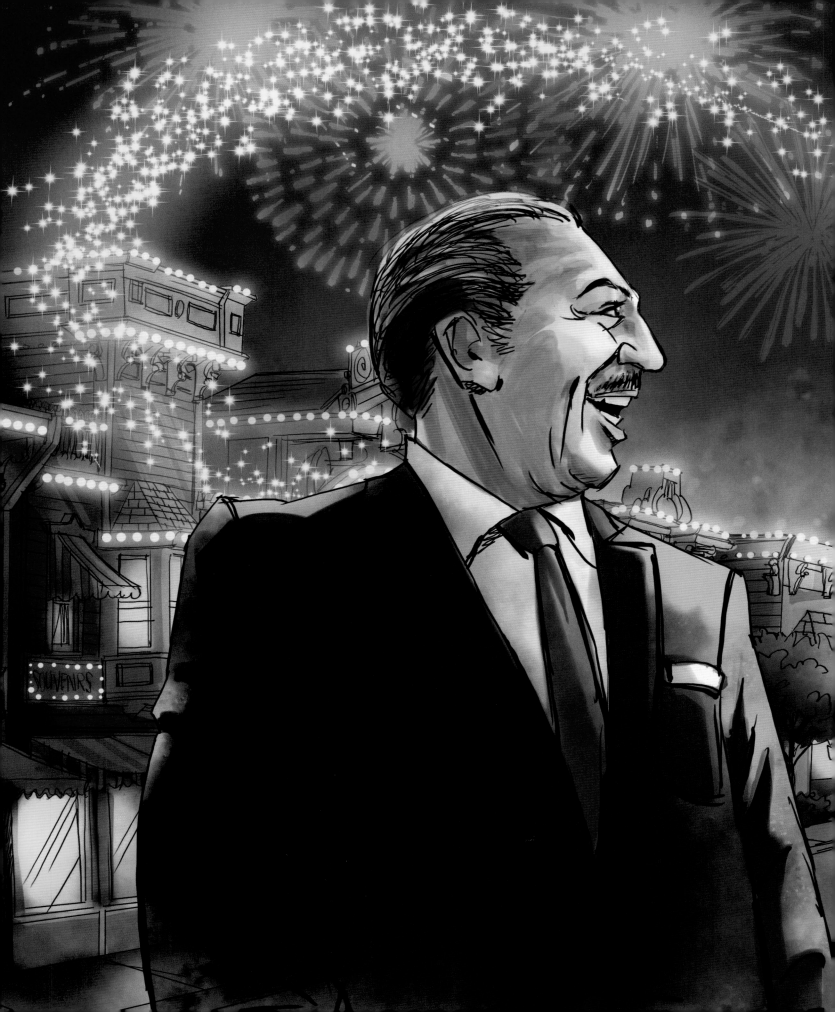

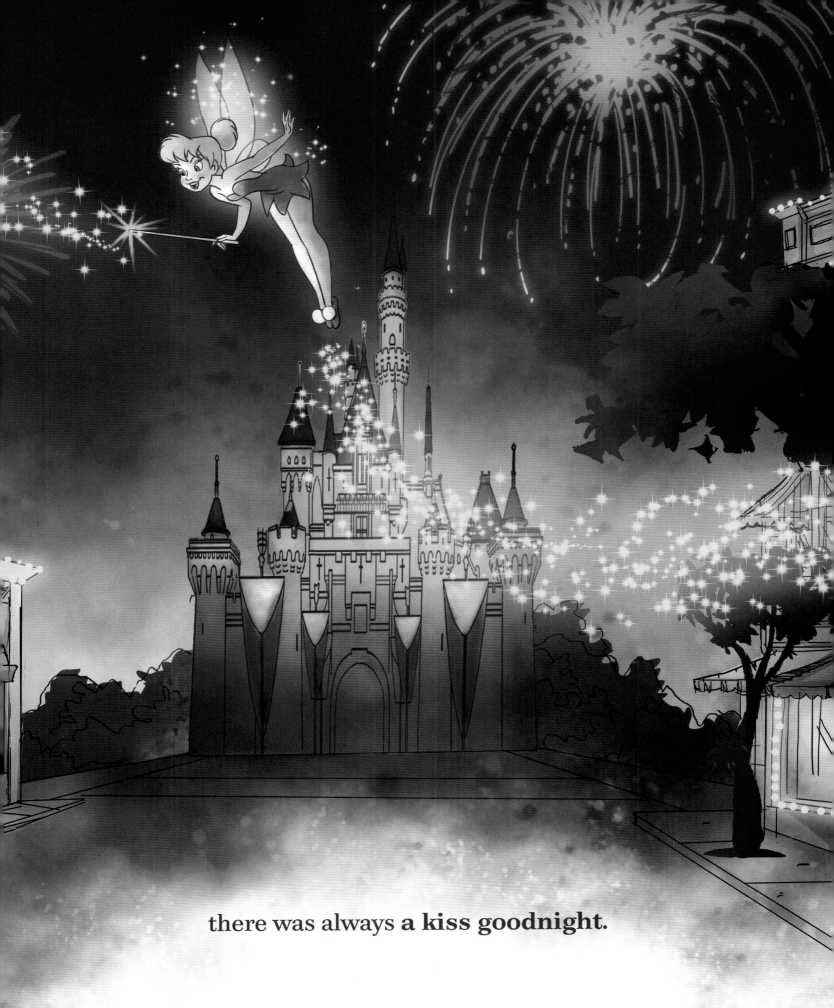

there was always **a kiss goodnight.**

A Kiss Goodnight

Music and Lyrics by Richard M. Sherman

To the land of imagination,
there's a wondrous magical door.
No one knows where the door is hidden,
yet we've all been there before.
For within every heart lies a secret
that reveals the mystery,
and the secret is this: just a gentle kiss
is the key.

A kiss goodnight
is the doorway to dreamland;
a kiss goodnight
is where mem'ries begin.

Just close your eyes,
and you'll see where your fantasies dwell;
to your surprise,
what a fabulous tale they tell.

A kiss goodnight
is the start of a journey
to deep in your heart,
where your memories shine.

All the joy
and the wonder you feel on your magical flight
begins with a kiss goodnight!

It begins with a kiss goodnight!

For information address Disney Editions, 1101 Flower Street,
Glendale, California 91201.
Printed in Malaysia
Reinforced binding

First Hardcover Edition, August 2017
1 3 5 7 9 10 8 6 4 2
FAC-029191-17097

ISBN 978-1-4847-8228-6